How is this art?

Untitled #1, 1979

Copyright © 2016 Lorenzo Servi and BIS Publishers.

Concept, text and design: Lorenzo Servi (www.serraglia.com)

Editing and proofreading: Helen Nodding

BIS Publishers
Building Het Sieraad
Postjesweg 1
1057 DT Amsterdam
The Netherlands
T +31 (0)20 515 02 30
F +31 (0)20 515 02 39
bis@bispublishers.com
www.bispublishers.com

ISBN 978 90 6369 418 0

ART IS EVERYWHERE

How to Really Look at Things

TABLE OF CONTENTS

INTRODUCTION

Most of us live in cities that develop as a result of the creative process of architects and urban planners. In turn, our everyday objects (from drinking glasses to cars) are conceived and produced by artists, designers, engineers and a range of other creative professionals.

Despite this fact, we rarely perceive anything extraordinary, or exceptional, within our daily interactions with such spaces and objects. The design process behind them is often taken for granted. Arguably, this is the result of form of visual laziness (a numbness, or lethargy) held towards our surroundings.

In contrast, when we visit a city for the first time, say as tourists, our senses seem to intuitively heighten; we become more alert. The world around us, and the objects within it, continually surprise and inspire us. There is often a desire, through the medium of photography, to document such experiences: coupled with an urge to communicate and share these encounters through social media.

Is it possible to be a tourist in our own city, village or local backyard?

But is it still possible to discover something wonderful and special without the necessity of visiting museums, monuments, or places outside of our habitual existence?

The goal of this book-project is to stimulate a desire to take a more careful look at our everyday world. To inspire you, the reader, towards a new interpretation of your familiar surrounds, and to illustrate how art can play a vital factor in this process.

Can objects as different as a colander and an oil painting—or a pink elephant and a blank canvas—really be considered within the same artistic realm? Can they exist as equals, as objects worthy of aesthetic contemplation, within the world of art?

The philosophy behind such thinking is neither quick nor simple to explore.

For this reason, and to avoid further misunderstanding, I choose to use the term "art" frugally. So, before continuing, try to clear your mind of any thoughts of it. Now, let's begin this story with a simple question:

In an empty and silent room with nothing to listen to,

how can you hear any music?

At every moment of the day we are surrounded
by many melodies encoded as radio waves.
However, it is impossible to listen to them

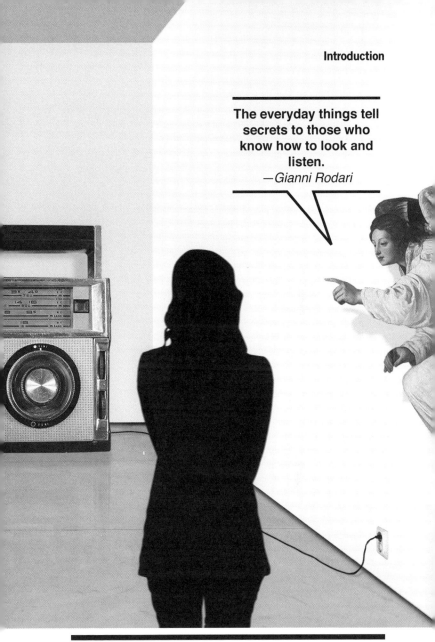

The everyday things tell secrets to those who know how to look and listen.
—*Gianni Rodari*

unless we have an appropriate tool, such as a radio.

The same goes for our vision and perception:

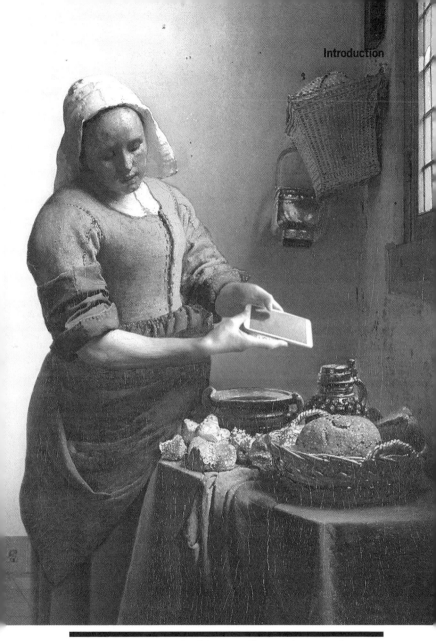

we are surrounded by endless visual stimuli, many of them already interesting and beautiful, but most of the time we just ignore them.

Almost without realizing it we (our senses together with the brain) place order upon these stimuli, based on their context and our prior experience. We reject those that do not interest us, or that we do not expect to see.

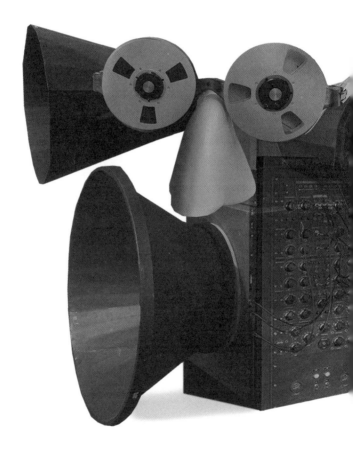

So, what is this instrument that allows us to find things of interest that would otherwise go unnoticed?

Here it is:

Now only €499

The Detector Machine and Amplifier of Senses (D.M.A.S.)*.

The real voyage of
discovery consists not in
seeking new landscapes,
but in having new eyes.
—*Marcel Proust*

I.
Time and
Slowness

IV.
Creativity

*
Unfortunately (or fortunately) such an instrument doesn't exist. Because in reality we need a set of physical and mental conditions.

There are five of them and they can be summarized as follow:

**II.
Expectations
and Context**

**V.
A (real)
Instrument**

**III.
Experiences**

I.

TIME AND
SLOWNESS

Optical illusions
exemplify the way in
which our brain works.
It constantly makes
assumptions about
what we see: in regular,
ordinary, symmetric and
simple ways.
It is a matter of survival.

**The Kanizsa square is not in fact a square,
but it creates the impression of one.**

The brain receives millions of sensory inputs per second (about 40 million) and looks for shortcuts to understand the world around us. In fact, our brain is constantly interpreting what we see:

we need to be able to make choices very fast.

But if, on the one hand, this primordial instinct can save our life in an everyday situation, on the other hand it can also make us visually lazy.

The result is that, within the context of our everyday routines, we do not see anything special: not because there is nothing interesting to look at, rather because our attention is pointed towards something more functional.

How often do we stop to look at things more carefully? How often do we spend every waking moment analyzing and questioning how the things around us work?

If we do not have the time to slow down and observe our surrounding with greater attention—or contemplate what we are really looking at— it is easy to imagine the difficulty of noticing something unexpected in an everyday place… like this stone, for example:

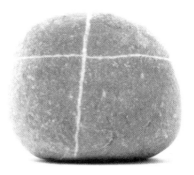

A stone.

PERCE

NEEDS

ATEN

↑ "Perception needs attention. Attention needs time." With this font called BRUNA (inspired by a lecture of Bruno Munari in Venice), I wanted to see how much of each letter could be eliminated without seriously affecting legibility.

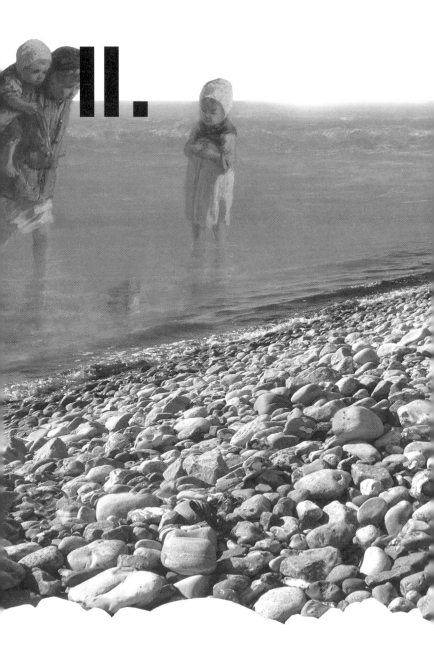

II.

EXPECTATIONS
AND

On a stony beach, a stone among many other stones will go unnoticed by most people.

It is more likely that the same stone will capture your attention when displayed in a museum of archaeology:

<u>CONTEXT</u>

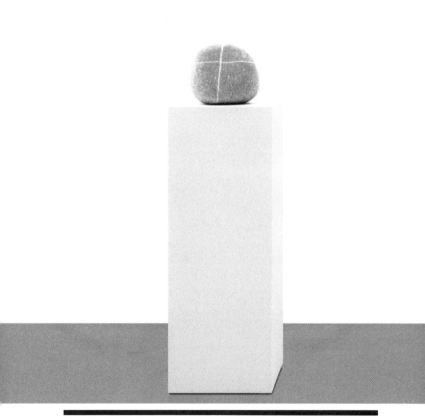

but would you look at it for more than three seconds?

Our brain allows us to focus upon just one thing at a time.

It has to prioritize what is most important, filtering what we see based on the object's context and our expectation. Thus, we see what we are expecting to see, not what we are looking at.

According to research, drivers checking the rear view mirror don't expect to see a two-wheeled vehicle—so these vehicles can be "missed". The UK Department of Transport estimates this phenomenon to be the cause of around 25% of all motorcycle accidents. Our brain filters what we see, based on our (unconscious) expectations.

In 2007, the Washington Post conducted an experiment examining the relationship between art and its context. The project explored how we appreciate art, specifically music, in a commonplace environment: questioning whether our perception of "beauty" fluctuates according to the time and place in which the experience unfolds. At a metro station in Washington DC, one of the world's most successful

contemporary musician's—Joshua Bell —played six Bach pieces, for about 45 minutes, with a violin worth $3.5 million.

During that time (at rush hour), it was calculated that thousands of commuters passed through the station. Two days before playing in the subway, Joshua Bell played a sold out show in a Boston theatre, where the tickets averaged $100 each. As Bell worked his way through a list of classical masterpieces, over a thousand people entered the metro station: only a handful stopped to listen. Whilst some dropped money in his open violin case (totalling $27), most did not even pause to watch.

What do we usually expect to see while walking on the streets? In a commonplace environment, how often do we notice unexpected things?

Even when we focus our attention, what we see will depend upon our expectations, which, in turn, are affected by spatial context and rooted in personal/cultural experience.

III.

**The only source
of knowledge is
experience.**
—Albert Einstein

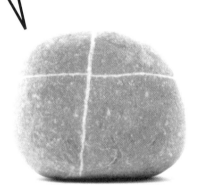

"A stone"—Smith J. (architect).

EXPERIENCES

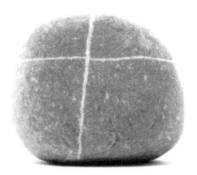

"It is a tombstone dating to the period between 568 and 571, the era in which the Longobards invaded Italy together with a groups of Saxons. The two crossed lines mean—rest in peace"—Parket H. (archaeologist).

The accumulation of experiences in life enables us to see things differently.

What I see right now is the result of my brain's answers to a series of basic questions that are processed through my senses. Are there any horizontal lines? Where and how many? Are there any contrasts of light? Are there corners, forms, movement?

To understand what is in front of us seems obvious, ordinary: but the scene that we see is actually the result of cellular activity. The cerebral cortex, in approximately a third of a second, edits our visual perception, resulting in our received view of the world.

Certain prefabricated objects, arguably, appear the same for all human beings; whilst others can be perceived differently, as a result of the experiences that we bring to them. Personal and cultural experience can influence the ways in which things appear to us.

Children, with their limited experience,

are constantly curious about how things work. Adults often believe that children are very creative, because their drawings, or conversation, enter into flights of fancy or imaginative realms. In reality, children are performing a very simple operation: they are projecting everything they already know onto all things they don't know in depth.

Being unfamiliar with the world, they apply similar, known, qualities to other things: the big stone is the mother of the little stone; if the stone gets dirty, it means it has pooped, and so on.

In growing more acquainted with the world (and its objects), during adulthood, we are less likely to question our relationship towards external reality. We may also begin to take certain things for granted.

This is why it is important to have, and store, as many experiences as possible (within the limits of the human possibilities), and why it is necessary to create connections between them, using the ability described in the following section.

IV.

CRE—

83
82 • • 84
81 •

1
• 80 85 •
• 2

• 79

• 78

• things

4 •
76 • 5 • 7 8 • 9 •
• 6

• connecting
74 •
73 •

72 •

60 59
• • Creativity •

• 61

71 •

is •

70 •

just •

69 •
64 •
68 •
67 • 66 • 65

47

ATIV—

ITY

37

Experiences and knowledge are important for defining who we are and how we see the world, but this does not mean that an adult's view of the world is better than a child's, or that the most experienced and cultured people see things in a better way than others:

the dictionary has all the words to create poems, but it doesn't contain any.

In other words, we should be able to make connections between what we see and what we already know, otherwise our knowledge and experiences are wasted.

Our brain continually makes assumptions about what we see in the simplest way, based on context, expectation and our past experiences. Such connections and assumptions give us an interpretation of what we are looking at.

But rather than accepting what our brain automatically suggests, if we try to make alternative connections, we can begin to see things differently.

In this way we can begin to identify things that we were unable to see before; we can interpret the same things in different ways; it is possible for us to create and inhabit a different world, even though we have actually not moved at all.

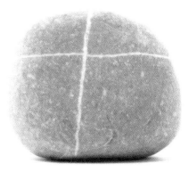

**"Seen from a distance it looks like an island"
—Munari B. (artist).**

**Even monkeys
are creative!**

The ability to create new relationships
between two (or more) things is called
creativity. This word is often used in the
art world and associated with something
mysterious or divine. But creativity is
not a talent. It is not a gift or a divine
intervention. It is a way of operating that
every one of us is already doing, at different
levels.

If a monkey wants a banana that is too high
to reach, it sees a wooden box on which it
has played many times before, establishes
the relationship between the different
heights (itself, the tree, and the box), climbs
on the case, and takes the banana.

A person without creativity would die of
hunger.

Sure!?

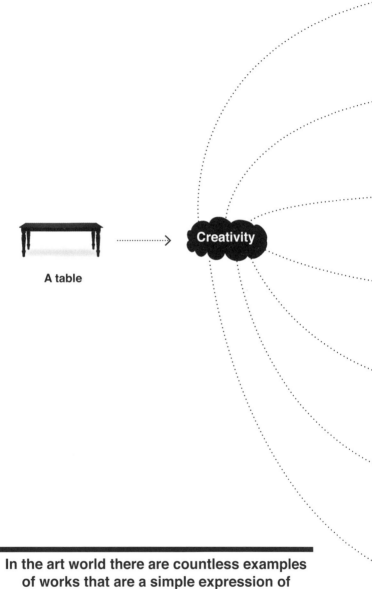

A table

⟶ **Creativity**

In the art world there are countless examples
of works that are a simple expression of
creativity.

↗ To see more examples, visit http://goo.gl/QKG3X1

> Opposites

> Visual or functional similarities

> Change of scale, context, material etc...

> Combine or repeat, same or different parts

> Collections

> Optical illusions

> Mixture of the examples above

V.

Artists are like detectives,
they find signs
that other people cannot see,
they confer meanings
where others cannot find any.

↗ 1. A book
2. A magnifying lens

(How To Be A Detective, Buster Keaton "Sherlock Junior", 1924.
By kind permission of Getty Images and the John Kobal Foundation).

A (REAL) INSTRUMENT

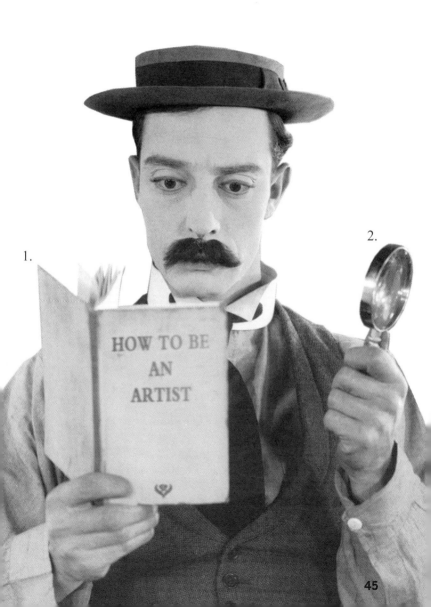

1.

2.

A (real) Instrument

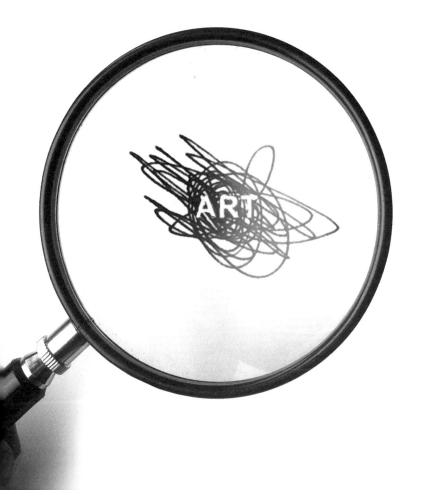

A (real) instrument is any kind of physical tool that can help to boost our senses and allow us to perceive our surroundings differently:

a pair of glasses, if we cannot see;

a magnifying lens, if we want to look at things more closely;

a sound recorder, if we want to listen more attentively for something we did not hear the first time;

a camera, if we want to concentrate our attention on a portion of the visual field.

Of course, there are also other more complicated and complex tools, like a nuclear space telescope, a book, a movie, or an art exhibition in a museum.

In fact, most artistically created works try to recall our attention to what and how to look at things around us, whether physical or emotional: things that we usually ignore or don't know how to interpret.

A (real) Instrument

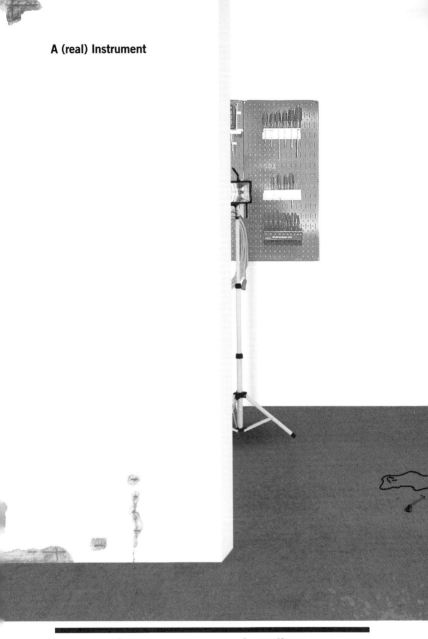

In every moment of our lives
we are surrounded by objects or situations

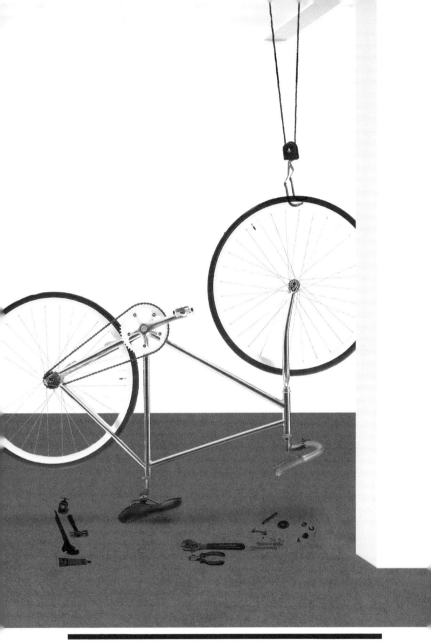

that may seem banal or unimportant.

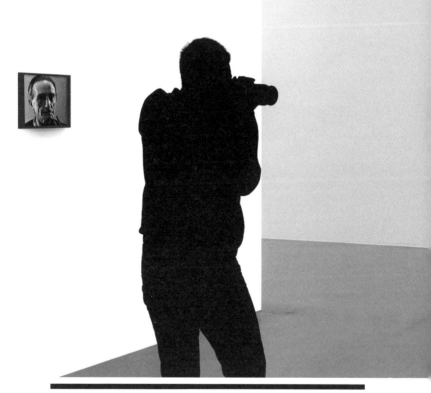

This is why some works of art help focus our attention on something that many people would otherwise not notice or appreciate

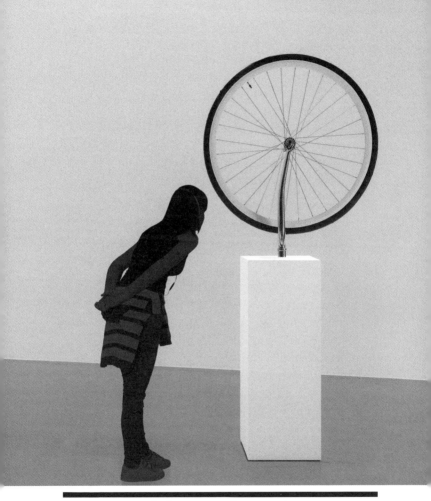

in its natural context.

From this perspective, a museum becomes an instrument, a sort of kaleidoscope: our attention is constantly stimulated to learn how to look, listen, and interpret what surrounds us differently.

People who do not know what a nuclear space telescope is or how to use one might easily end up considering it useless or inessential to their lives.

This is similar to how many people consider contemporary art.

People truly want to understand contemporary art, but they may become confused and perplexed. So they reject every form of art that they do not consider a true copy of reality, preferring art where they can, at least, recognise the manual abilities of the artist, even if they could not themselves explain or replicate them.

This is why it is important to understand what art is and how it can be used.

Art today is a new kind of
instrument, an instrument
for modifying consciousness
and organizing new modes
of sensibility.
—*Susan Sontag*

WHAT IS
ART?

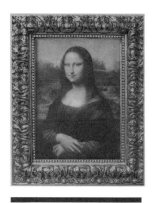

Art

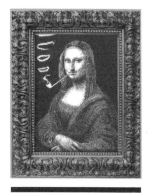

Art

1500

Art

Art

Art

··>

2016

Art

The word "art" is not easily defined. New forms of art are continuously born: thus, the meaning of the word "art" changes with time and context.

When, in the early twentieth century, an artist called Marcel Duchamp began to introduce the public and critics to his ready-made, common artefacts of daily use, such as: a coat rack, a bottle rack, a urinal, etc., the meaning of art should have changed dramatically and, with it, the meaning of life itself.

But it didn't. Instead, artists continued to produce incomprehensible objects, and many people, museums, and galleries continue to expose them.

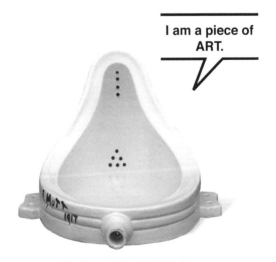

I am a piece of ART.

A few years later, John Cage tried again to push the boundaries of art. During a concert in New York, he remained in silence for 4 minutes and 33 seconds, in order to focus the attention of the spectators on the random noises that they could hear when the musicians were silent. Such sounds included the fall of an object, the hum of an insect, or the breathing of the spectators themselves.

But something went wrong again.

To date, there are 17 replicas of Duchamp's urinal in existence. As well as frequently appearing in international exhibitions, one is also held in the Tate's prestigious art collection.

The 4 minutes and 33 seconds of silence is available today on iTunes for 0.99 €.

In other words, these extreme attempts to open our eyes to what is already around us (or what is within us) became ends in themselves.

These kinds of works, along with many others, that should have evoked changes in the meaning of art, instead, have given museums and contemporary artists' an excuse to focus on the object—art for the sake of art.

When the wise man points at the moon, the idiot looks at the finger.

In other words, looking at me you should contemplate the idea of beauty and not just my bottom.

Contemporary art is moving further and further away from making a connection with most people.

Today, it is easy to see the result: museums are filled with a multitude of objects that are passed off as art. Unique pieces are auctioned at thousands of euro (or more). Works of questionable quality and aesthetics have been thrown away by mistake by the cleaning staff of a museum.

The expectations of visitors to museums of contemporary art are increasingly being disappointed.

To put it simply, people are confused.

Is this my portrait or am I looking in a mirror?

But, if a work of art can make us see things from another point of view, if it can function as a window through which we see the world differently, then, by standing in front of it and contemplating it, you may get a feeling close to the experience of being in the most wonderful place you have ever visited as a tourist, for the first time, with your lover, after having a double espresso.

How can I look
for art?

That's why it is important to remember that art is not necessarily an object, and it is not necessary inside museums or art galleries only: art can be found (and experienced) everywhere, if you only know how to look and listen for it.

Looking is not as simple as it looks.
—*Ad Reinhardt*

ART IS EVERYWHERE:

A new kind of instrument

Art is Everywhere: The Workshop started as a self-initiated project in 2005, and over the years has become an open two-day workshop for art galleries, museums, festivals, and schools.

It aims to create an alternative guide to a city by highlighting objects, colors, shapes, and parts of the urban landscape that normally go unnoticed.

During the workshop, participants are invited to explore the city with new eyes, completing small assignments and documenting their findings with photographs.

The workshop highlights the role of a contemporary artist as someone who analyzes and processes daily stimuli to

THE WORKSHOP

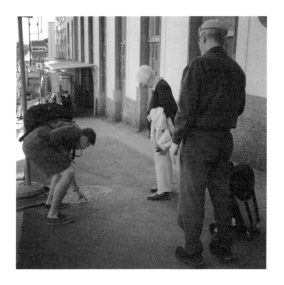

create "new meanings" that can change the viewers' perception of their surroundings, if not the reality itself.

The experience culminates in the creation of a collective map or guide that will stimulate future visitors and the participants themselves to visit and observe the city from an alternative, more curious point of view.

↑ "What are you looking at?". During the workshop, a participant has caught the attention of two pedestrians. Helsinki, 2014

What follows is a series of images of found objects (colors, shapes, or anything else), in no particular order, from workshops, self-discovery, and the official Flickr group*. These give you an idea of what can be found whilst walking around the city.

* A special thanks to the photographers who contributed their wonderful images. Please note that the captions are not the photographers' own.

?!

Locks Without Doors
Helsinki

There are many buildings in Helsinki (and not only here) where on the façade there are a series of holes, some of which contain locks. Is this a publicity stunt by a company that makes locks? Or is it the work of a street artist? Probably, there is more than one author because the holes seem to have been made with different techniques and at different times. Most of these locks are at the same height, separated from each other by 8-10 cm. They seem, almost, to follow a logical sequence, a predetermined pattern. Who was the first to begin? And from where? Was the second person following a predetermined pattern designed by someone else or are these the result of spontaneous intuition?

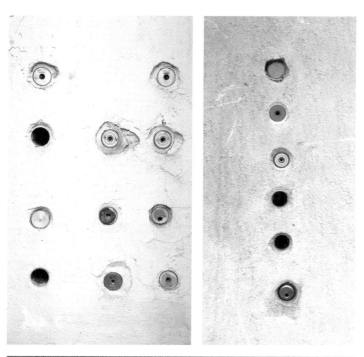

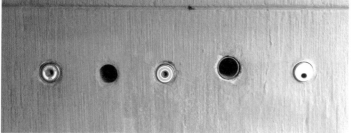

Opposite Bin
Berlin

Normally, a plastic bag is placed inside a
rubbish bin to collect the garbage.
But what is the "opposite" of a bin?, the
creator of this work might have asked.
Here, the plastic bag covers the bin, so its
true identity is exposed to any who pass by.

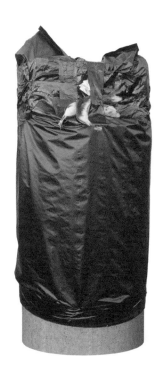

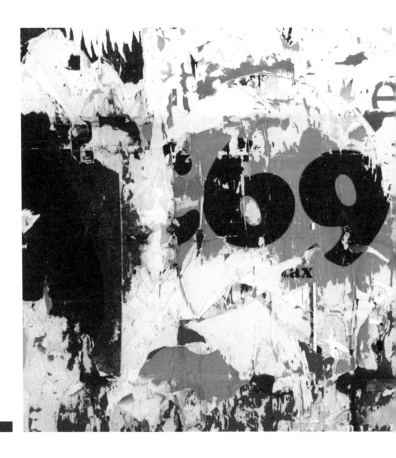

69
London

This work shows the remnants of different
posters stuck to a black metal surface. I
thought of the posters by Mimmo Rotella.
If this had been exhibited at the Venice
Biennale, I would not have given it a
second look. But here, is it the unusual

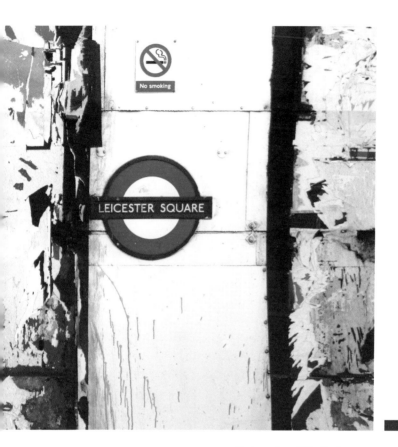

Photo courtesy of Glen Scott

location that makes this work worth looking at? Did the anonymous author who made it, purposely leave out the "69" or was he just too lazy to remove everything? And what does he want to communicate to us?

Secret Poem
London

At first look, it appears that these signs seem to have been made randomly, but when we look at them more carefully we realize that they might be following a— language like—precise pattern and rules. If we look more closely, we can discover the small English subtitles left behind on those illegible signs. It is very rare to find a work with such an explicit explanation.

Photo courtesy of Maartje Jaquet

Souvenirs
Prague

Prague has been having problems with traffic for many years, especially on the main roads. The latest initiative is to rid Prague of cars and their pollution, so more and more measures are being taken to prevent parking in the city. This is why the most convenient and safe parking is in secure lots or parking garages. And don't, whatever you do, park in a forbidden zone: by using the latest technology the city can now disintegrate your car in a few seconds leaving only the tires as souvenirs.

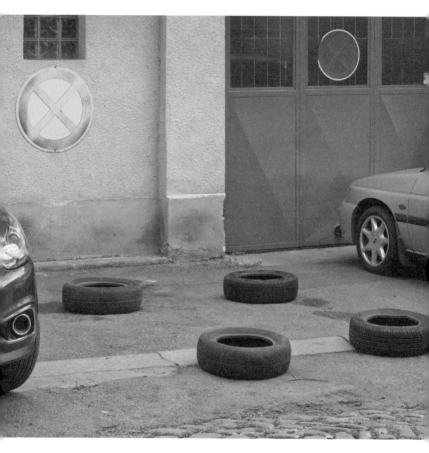

Photo courtesy of Goran Patlejch

The Cliff Rocks And Sunset Over The Sea
Detroit

This found painting is divided almost in
half by a diagonal line. The clearer part
on the right seems to represent a rocky

Photo courtesy of Carol Murray

cliff, while the left seems to represent a
sunset over the sea. We do not know which
specific place is depicted.

Puzzle Sign
Stockholm

This sign hasn't only lost its original colors.
It has revealed that in reality it is not a
symbol of a dog, but a puzzle that we can
work at as we please.

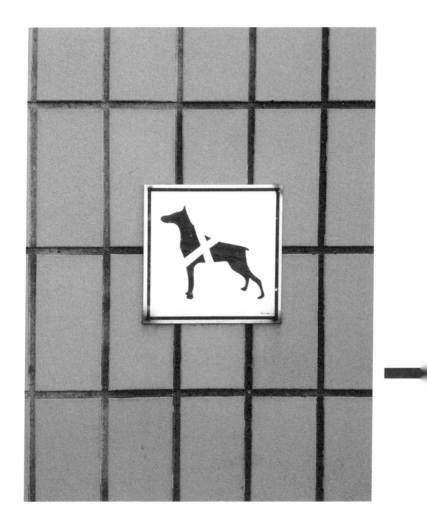

Green Spot
Copenhagen

Green spaces in urban areas are usually planned by a City Planning Department. But this green area is too small for a children's playground or even a dogs' exercise park. Who designed this green space? And why? Is it a park made only for ants or other small creatures? Or is it just a joke made by a city gardener?

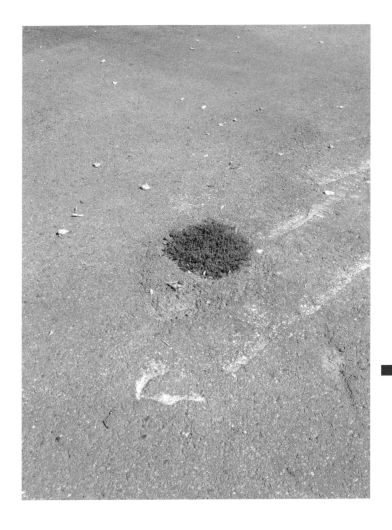

The True Value of Money
London

Two ATMs have been hidden under a white plastic cover by the author of this work. A roll of yellow and black tape has been used to draw two big X's, probably to symbolize the unknown value of what is underneath. To reinforce the message, the two plastic covers are slightly open, giving a glimpse of the two money machines: what is the true value of money?

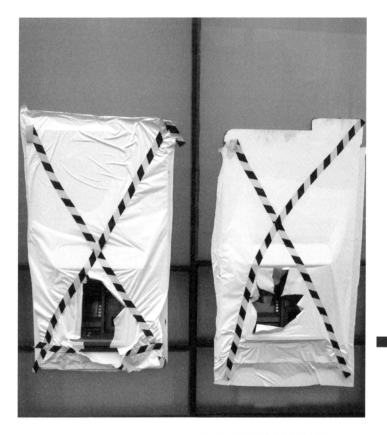

Photo courtesy of Nicholas Lockyer

The Machines' Protest
Tokyo

Japan has the highest number of vending machines per capita, with about one machine for every twenty-three people. Vending machines can be found all over cities, towns and even in the countryside. But in this part of Tokyo, Shibuya, it seems the machines are leading an autonomous life. They are down on the street standing just next to the cars. Where are they headed all together? What are they protesting about? Is the price of hot drinks too low?

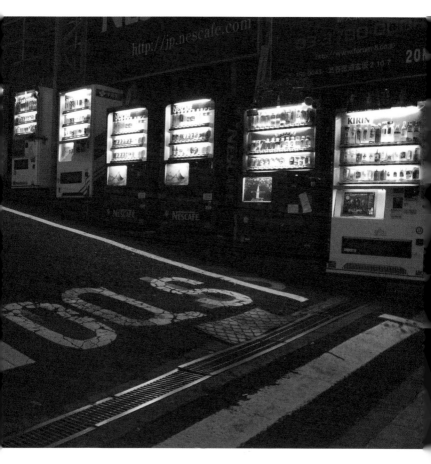

Photo courtesy of Chie Rokutanda

Last-Minute Naps
NYC

New York City offers a great variety
of food, shops, art, experiences and
opportunities. As in many other big
cities, people are often rushing between
jobs, going places, etc… For those who
have some free minutes, the city offers
mattresses for last-minute short naps. Free
of charge.

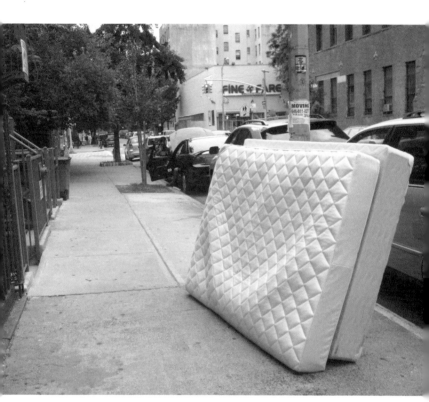

Photo courtesy of Steven Matthews

Street Cartoons
NYC

Sidewalks offer often incredible stories.
Here, for example, an anonymous author
made a dog-shaped silhouette looking left.
On the top of his head, there is a thought
bubble, which has been left empty by
the author. Does the dog really have no
thoughts? Or is it just that we don't know
how to interpret them correctly?

Photo courtesy of Maartje Jaquet

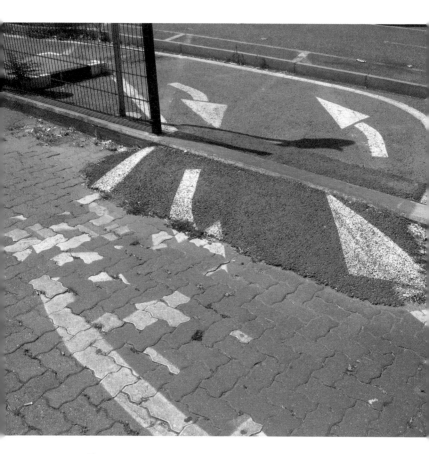

Photo courtesy of Michele Aquila

Urban Puzzle
Torino

These paving stones in the street were
probably lifted after the lines had already
been painted. When the author of this work
relaid them, we don't know exactly what
happened: did he want to reinterpret the
classic arrow shape into something new
and original? Or was he just too lazy to put
them back in order? Or maybe we can still
move them, so that anyone who passes by is
free to compose what they want?

Wrapped Desires
Los Angeles

When we give a present to someone we
love, we do our best to wrap it neatly.
Wrapping monuments or other things
on different scales is quite often used
by-so-called-artists too. However, it is
often forbidden to unwrap things that are
meant to be a work of art. This leaves a
philosophical question: is it better not to
unwrap something and continue to imagine
what is inside, or is it worth unwrapping it
at the risk of being disappointed?

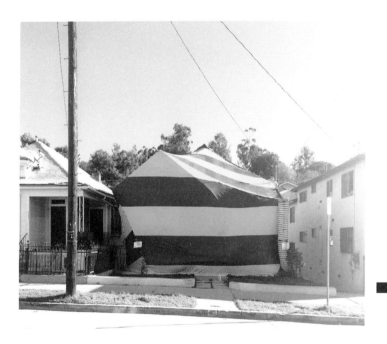

Photo courtesy of Karen (kweber222)

Hidden Animals
Melbourne

When rabbits were introduced by European
immigrants to Australia, they bred out of
control and ate the farm crops and food
that both native and farm animals needed.
Farmers hunted the rabbits, and also
brought in cats to keep the numbers of
rabbits and rats down. These introduced

Photo courtesy of Peter Schofield

cats created another problem, becoming predators of local species. Animal control is still an important program of the Australian federal and state governments. This is why walking in the street—it is easy to notice animals trying to hide themselves so that they are not caught by the authorities.

Archipelago
Bruxelles

A study suggests that pedestrians should
stare at oncoming drivers to reduce the
chance of getting hit when crossing the
street. In fact, it isn't very safe to cross
a street without looking right and left.
However, sometimes your eyes risk being
hit by something extraordinary if you look
down too: an archipelago in full view.

Photo courtesy of Olivier Vancayzeele

A City Family
Helsinki

Seeing faces in many ordinary objects is a widespread psychological phenomenon called pareidolia, but some objects seem animated, even if they don´t have an identifiable "face". These strange cable boxes look like a family lost in city traffic, and the three children are clearly frightened. The mother is there to protect them, but where are they headed?

CONCLUSION

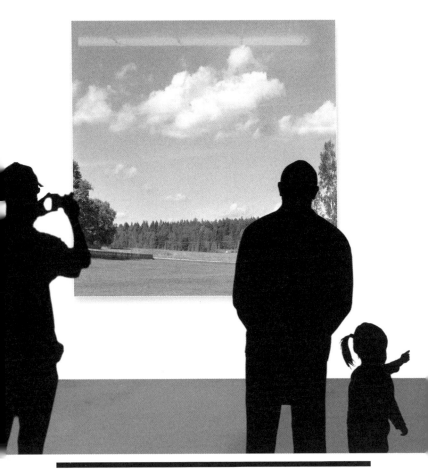

It all depends only on you: how you look at it,
the meaning you give it, and

how you frame it.

Conclusion

Looking at the four dots, it is quite common to feel you are seeing a square.

We cannot know how the person next to us sees the world. But a work of art is the tangible proof that things are seen from different points of view.

Whether it is the scenes of everyday life portrayed in the still life and landscape paintings of the 1500s, Duchamp's ready-mades, the 4 minute 33 second concert by John Cage, or the anonymous landscape photographs of the New Topographics movement (to name but a few), artworks repeat the same thing through the ages using whatever tools were contemporary for that time.

Every moment of our lives, even the most banal or sad, can be considered to be art materials: they can be transformed into something different, new, or exciting. It depends only on you: how you look at them, the meaning you give them, and how you frame them.

But this doesn't mean that everyone sees
the same thing or that you couldn't see it in a
different way.

An artwork can enable us to visualise the world through the eyes of others: giving us the chance to see familiar aspects of the everyday from a fresh perspective.

In other words, art reminds us that there is not one singular way of doing and seeing things, that problems can have more than one solution, and questions more than one answer.

And, above all, that every story can end however you want. If you want it to.

My story, for example, ends like this.

SOURCES AND INSPIRATIONS

WEB

"$1.1 million sculpture damaged by cleaning woman in German museum", Maura Judkis, Washington Post (2011) http://goo.gl/Jov6PZ

Art is Everywhere, Flickr group https://goo.gl/SZjEeY

"Art Which Can't Be Art" Alan Kaprow (1986) http://goo.gl/fp2hr0

"Cleaner bins rubbish bag artwork", BBC News (2004) http://goo.gl/42iGuJ

"Cleaner clears up Hirst's ashtray art", The Guardian (2001) http://goo.gl/ABDPyG

"Even in tough times, contemporary art sells", https://youtu.be/_mHVy_hH8vc

Inge Druckrey: Teaching to See (2012) https://vimeo.com/45232468

"Overzealous cleaner ruins £690,000 artwork that she thought was dirty", The

Guardian (2011) http://goo.gl/4U8pW3

"Pearls Before Breakfast", Washington Post Staff Writer (2007) http://goo.gl/8NNXaa

BOOKS

A Year With Swollen Appendices: Brian Eno's Diary, Brian Eno, 1996 (Faber & Faber)

Design as Art, Bruno Munari, 2008 (Penguin Classics)

Everyday Aesthetics, Yuriko Saito, 2008 (OUP Oxford)

Fantasia, Bruno Munari, 1977 (Laterza)

How to Look, Ad Reinhard, 2013 (Hatje Cantz)

How to Visit an Art Museum, Johan Idema, 2014 (BIS Publisher)

On Looking: A Walker's Guide to the Art of Observation, Alexandra Horowitz, 2012 (Scribner)

Six Years: The Dematerialization of the Art Object from 1966 to 1972, Lucy Lippard, 1997 (University of California Press)

Super Normal: Sensations of the Ordinary, Naoto Fukasawa and Jasper Morrison, 2007 (Lars Muller Publishers)

The Art of Looking Sideways, Alan Fletcher, 2012 (Phaidon)

Ways of Seeing, John Berger, 1972 (Penguin)

For a full list visit **http://goo.gl/O1jnuH**

The inspiration for this book came from the work of Bruno Munari, one of the first artists who, already in the 1940s, developed art workshops for children and introduced radical ideas on how to make art more accessible for everyone.

ABOUT
THE AUTHOR

SerraGlia is the alias of the Italian architect and visual ~~artist~~* designer, Lorenzo Servi (born 1979).

Through painting graffiti, SerraGlia first discovered cities and their untapped visual environment. Having finished a master's in architecture (2008, University of Florence), he focused his interest on the intersection of digital photography and graphic design. In 2010 he founded LUMART, an architectural visualization studio based in Helsinki.

Parallel to his commissioned works, SerraGlia is constantly researching and analysing issues in everyday life and built environments, and using them as the basis for creating self-initiated projects documented through photography, video and publication. His projects sit between the domains of reality and fiction.

In 2012, SerraGlia started to focus on how to make contemporary art more accessible to everyone by founding the Imagined Museum of Contemporary Art, and by holding workshops in Finland and abroad.

* I am very uncomfortable with calling myself an artist because the term has been abused and causes unnecessary confusion. Moreover, I think it is qualitative and not just a simple title.

Stop thinking about art works as objects, and start thinking about them as triggers for experiences. (...) Art is something that happens, a process, not a quality, and all sorts of things can make it happen. What makes a work of art "good" for you is not something that is already "inside" it, but something that happens inside you—so the value of the work lies in the degree to which it can help you have the kind of experience that you call art.

—*Brian Eno*

Untitled #1, 1979